MASKS

Devised and illustrated by

Clare Beaton

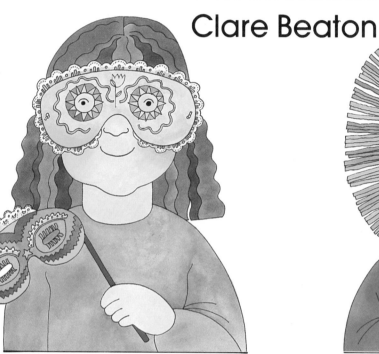

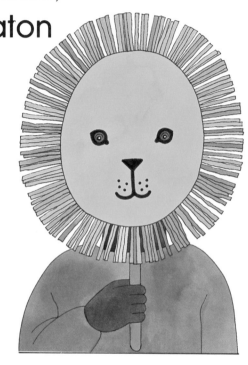

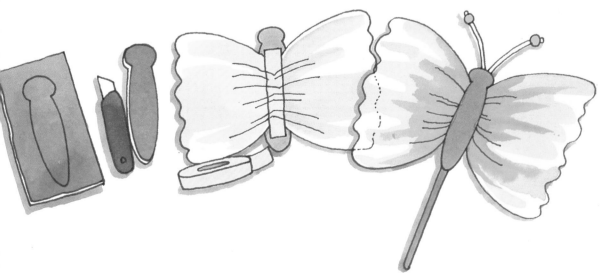

WARWICK PRESS

Contents

Produced by
Tony Potter, Times Four Publishing Ltd

Conception and editorial:
Catherine Bruzzone, Multi Lingua

Published by Warwick Press, 387 Park Avenue South,
New York, New York 10016, in 1990
Paperback edition published by Franklin Watts,
387 Park Avenue S., NY, NY

First published in 1990 by Grisewood & Dempsey Ltd,
London.

Typeset by TDR Photoset, Dartford
Colour separations by RCS Graphics Ltd
Printed in Spain

Library of Congress Cataloging-in-Publication Data

Beaton, Clare.
 Masks / Clare Beaton.
 p. cm. – (Make and play)
 Summary: Depicts a variety of masks and how they can be
 papier-mâché, construction paper, string, and other material
 Includes related activities.
 ISBN 0-531-15163-8 ISBN 0-531-19098-6 (lib. bdg
 1. Masks – Juvenile literature. [1. Masks. 2. Handicraft.]
 I. Title. II. Series.
 TT898.B43 1990
 731'.75–dc20

About this book

This book will show you some easy and fun ways to make masks. There are step-by-step instructions for seven main masks and ideas for lots more at the end of the book.

On the left-hand pages, there are four simple steps to follow:

On the right-hand pages, there is the finished mask with some extra suggestions for you to try:

The simplest masks are at the beginning of the book and the more complicated ones at the end. You should be able to find most of the materials you need in your home. Look at pages 4-7 for some helpful hints.

You can make the easiest masks very quickly but you will need to plan, and perhaps shop, for some of the others. The extra masks at the end of the book do not have step-by-step instructions but most can be made in similar ways to the main masks.

Warning

With this book, older children should be able to make all but the most complicated masks on their own. However, they may need adult help occasionally and younger children will need help and supervision. It is worthwhile teaching children to use tools such as craft knives correctly and safely right from the start.

Take special care with tools such as scissors, knives, and staplers, and use non-toxic children's glue and paint. Craft knives with blades which retract into the handle are recommended, as are round-ended scissors.

Take extra care where you see this symbol:

Materials

Keep a box of oddments that can be used to make things: cardboard boxes and packages, cardboard tubes, sticks, feathers, beads, buttons, material, papers, doilies, string and anything colorful and decorative. You could buy old net curtains, lacy material, scarves, old jewelry, and so on, at rummage sales.

Keep ribbons and trimmings from presents and candy boxes.

Even the boxes from candies or prese may come in useful.

Felt is wonderful to use. It doesn't fray and comes in lots of brilliant colors. You can sew it or glue it.

Look out for feathers, dried leaves, and grasses when you are out for a walk. If you need a lot of feathers, try asking at a farm or a butcher'

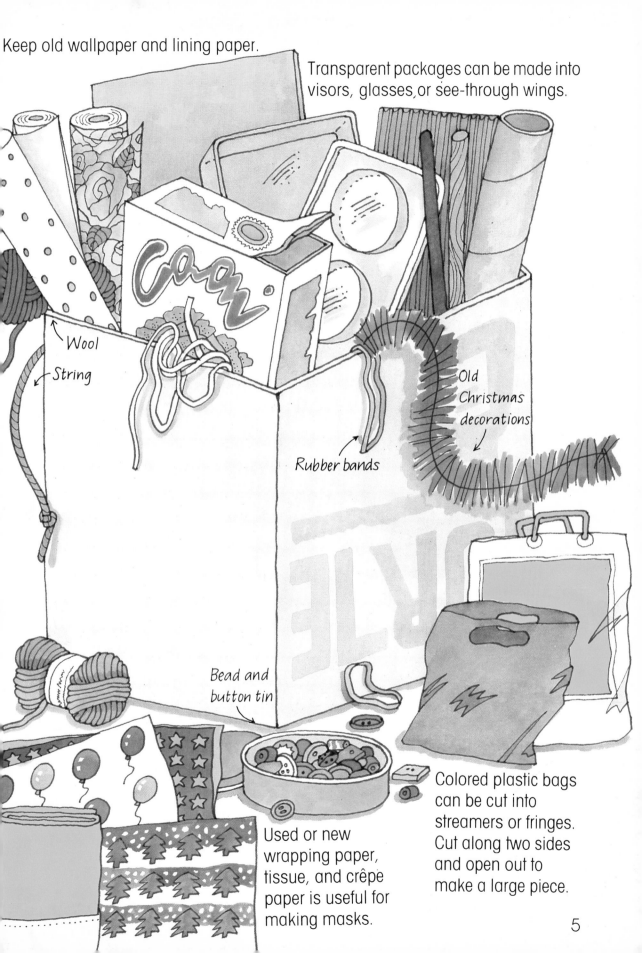

Keep old wallpaper and lining paper.

Transparent packages can be made into visors, glasses, or see-through wings.

Wool

String

Rubber bands

Old Christmas decorations

Bead and button tin

Used or new wrapping paper, tissue, and crêpe paper is useful for making masks.

Colored plastic bags can be cut into streamers or fringes. Cut along two sides and open out to make a large piece.

5

Hints and tips

A sewing basket will have lots of things you need, such as scissors, pins, needles, and thread. Don't forget to ask the owner first, before you begin! It's a good idea to build up your own store of different kinds of elastic, buttons, ribbon, braid, safety pins, and anything decorative and fun that might come in useful.

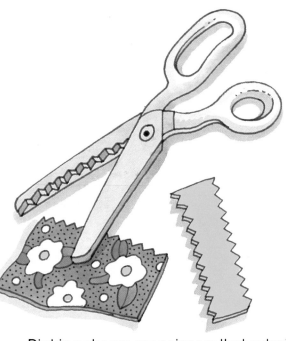

A small stapler is very useful for joining things, such as thin elastic to card (instead of sewing) or a band of paper or card (instead of using sticky tape). Do make sure that the staple ends are closed properly and don't leave staples lying around.

Elastic

Staple

Staple

Pinking shears are scissors that cut with a zigzag to stop material from fraying. They are also useful because they make a pretty edge.

A paper hole puncher is also useful and fun to use. You can use one to make patterns.

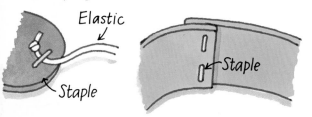

Pattern of holes

A sewing machine is useful but is not essential and is best used only by an adult. Hand sewing will do fine.

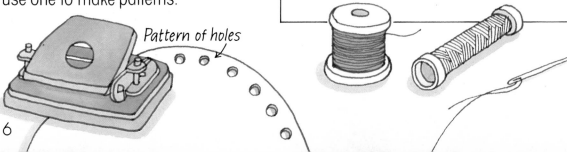

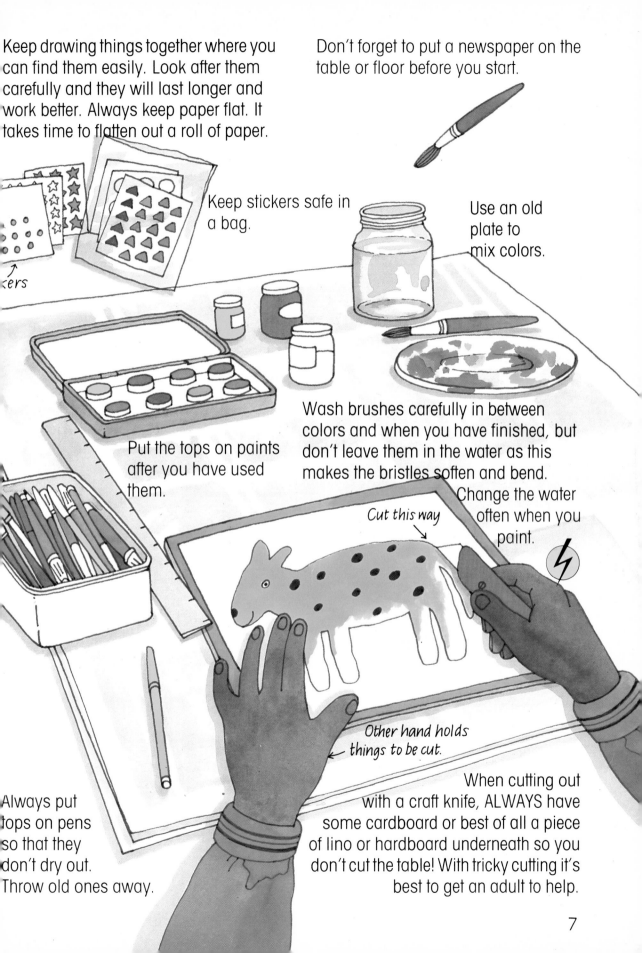

Keep drawing things together where you can find them easily. Look after them carefully and they will last longer and work better. Always keep paper flat. It takes time to flatten out a roll of paper.

Don't forget to put a newspaper on the table or floor before you start.

Keep stickers safe in a bag.

Use an old plate to mix colors.

ers

Put the tops on paints after you have used them.

Wash brushes carefully in between colors and when you have finished, but don't leave them in the water as this makes the bristles soften and bend.

Change the water often when you paint.

Cut this way

Other hand holds things to be cut.

Always put tops on pens so that they don't dry out. Throw old ones away.

When cutting out with a craft knife, ALWAYS have some cardboard or best of all a piece of lino or hardboard underneath so you don't cut the table! With tricky cutting it's best to get an adult to help.

Ears

1 Draw the outline on thin cardboard. Then mark the zigzag line and the eye holes.

2 Cut out the mask and the eye holes. Paint it light brown.

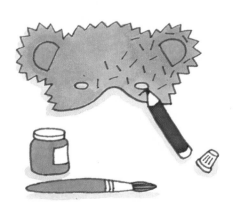

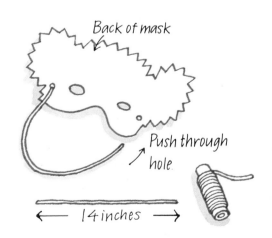

3 When it dries, paint the ears pink. Then draw on "fur" lines in black.

4 Lastly, make two tiny holes. Put in some thin elastic and knot each end.

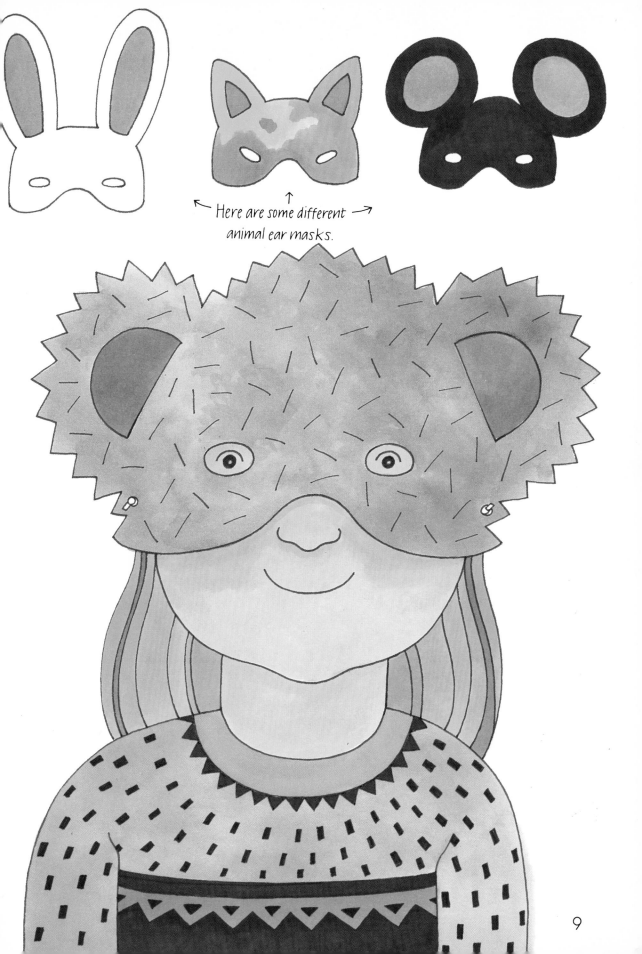

← Here are some different →
↑
animal ear masks.

Lion

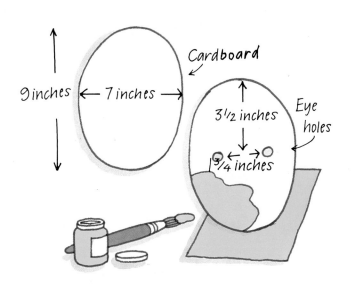

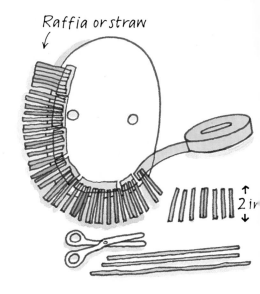

1 Cut an oval and make eye holes. Paint, or cover one side with yellow paper.

2 When dry, turn over and tape straw or raffia all around the oval shape.

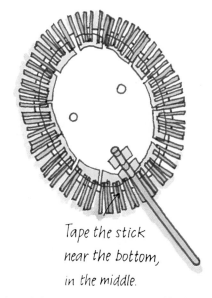

Tape the stick near the bottom, in the middle.

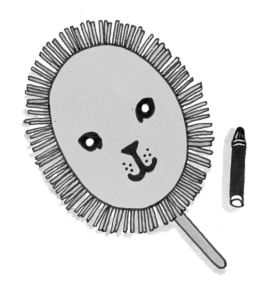

3 Next tape a small stick firmly in place under the eye holes as shown.

4 Turn over and draw a nose and a mouth in black. Draw around the eye holes.

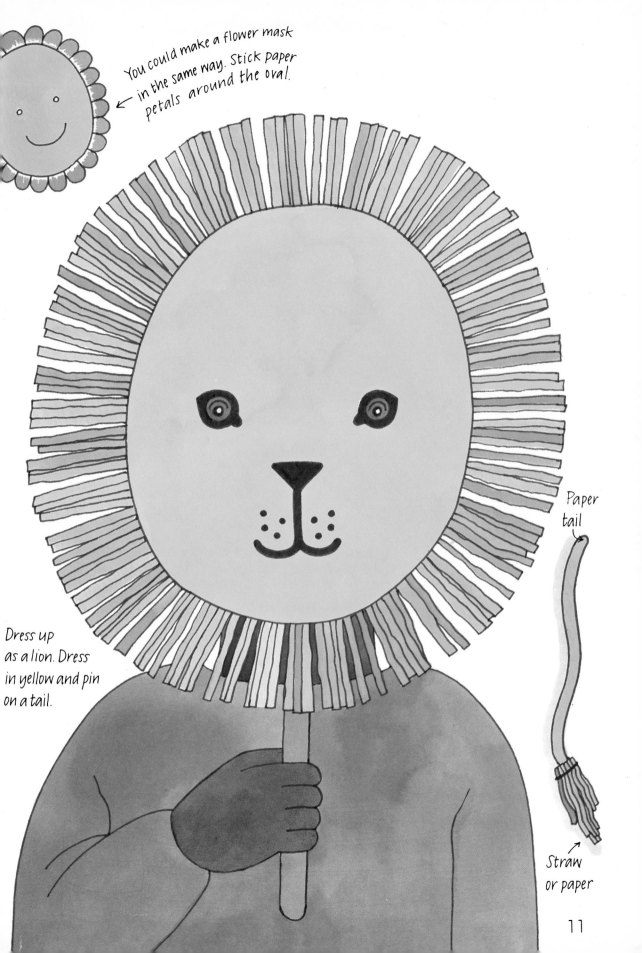

You could make a flower mask in the same way. Stick paper petals around the oval.

Paper tail

Dress up as a lion. Dress in yellow and pin on a tail.

Straw or paper

11

Insect

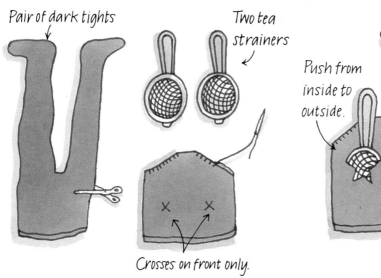

Pair of dark tights

Two tea strainers

Crosses on front only.

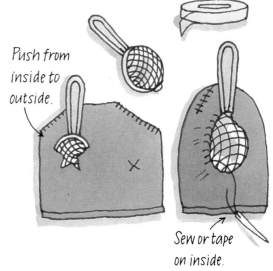

Push from inside to outside.

Sew or tape on inside.

1 Cut the legs off a pair of tights. Sew them up. Cut two tiny crosses.

2 Push the strainers through the holes. Tape or sew the edges to the inside.

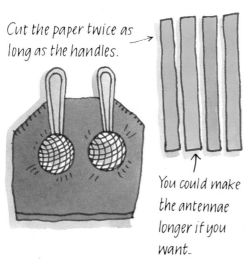

Cut the paper twice as long as the handles.

You could make the antennae longer if you want.

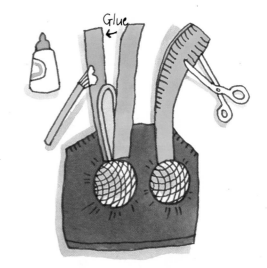

Glue

3 To make the antennae, cut four strips of colored paper wide enough to cover the handles.

4 Stick the paper to the handles. Round off the ends. Cut fringed edges.

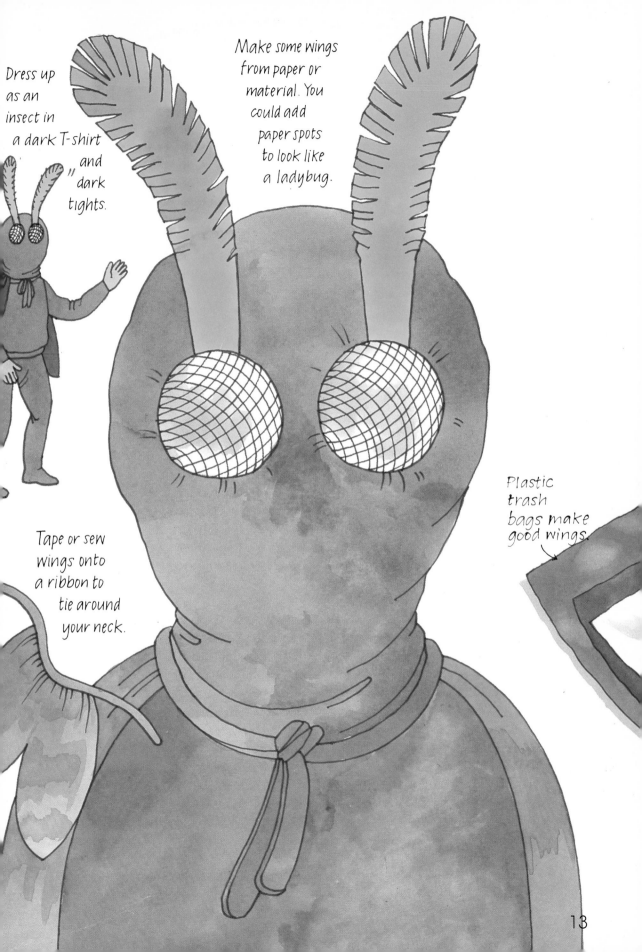

Dress up as an insect in a dark T-shirt and dark tights.

Make some wings from paper or material. You could add paper spots to look like a ladybug.

Plastic trash bags make good wings.

Tape or sew wings onto a ribbon to tie around your neck.

13

Knight

1 Draw a 5-inch square on thin silver card. Then add the shape shown and cut it out.

2 Make up a pattern you can see through and cut it out. Work on the back.

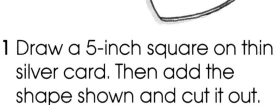

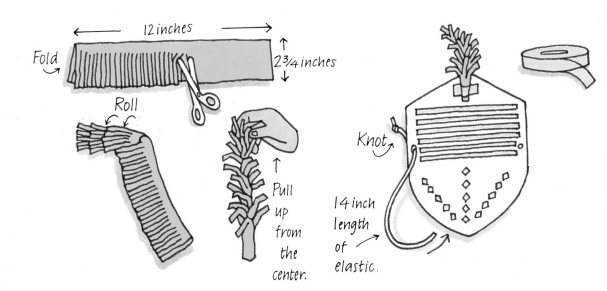

3 Now cut a strip of crêpe paper for a plume. Fold it in half and cut a fringe. Roll it up.

4 Tape the plume on the top of the mask. Make two small holes and put in the elastic.

14

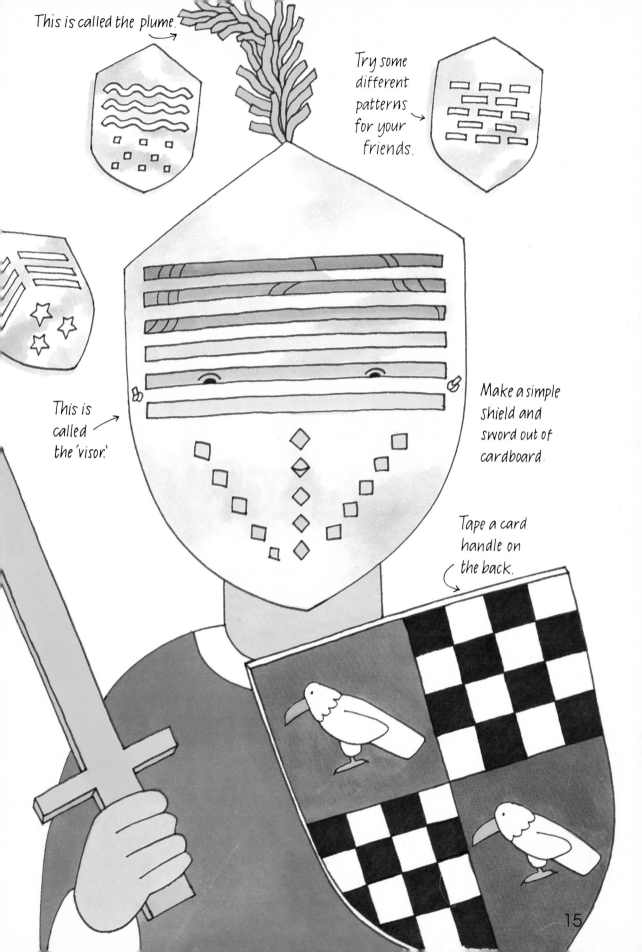

This is called the plume.

Try some
different
patterns
for your
friends.

This is
called
the 'visor.'

Make a simple
shield and
sword out of
cardboard.

Tape a card
handle on
the back.

15

Starry eyes

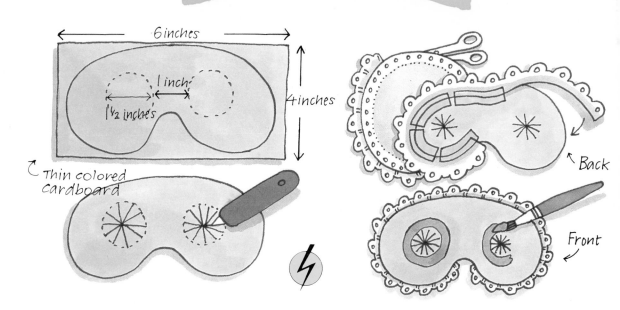

1 Draw a mask shape and two circles. Add the "star" lines and cut along them.

2 Tape the edge of a paper doily around the mask. Paint around the cut stars.

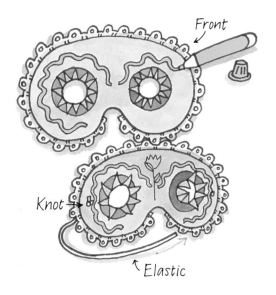

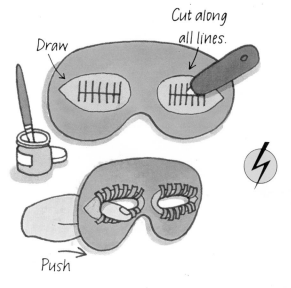

3 Finish decorating the mask. Push out the cut stars. Add the elastic.

Make a mask with different eyes. Cut a fringe instead of a star and push out.

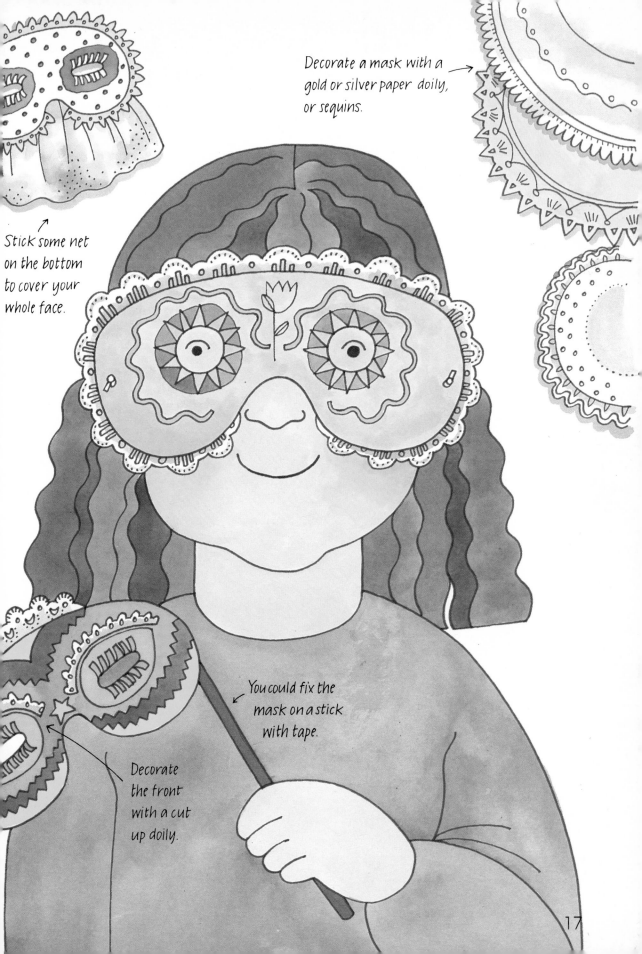

Decorate a mask with a gold or silver paper doily, or sequins.

Stick some net on the bottom to cover your whole face.

You could fix the mask on a stick with tape.

Decorate the front with a cut up doily.

17

Carnival

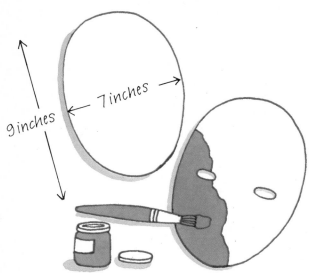

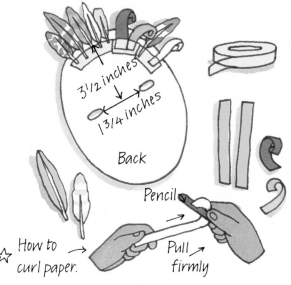

1 Cut an oval out of cardboard and make holes for the eyes. Paint it blue.

9 inches

7 inches

2 When dry, stick on feathers and strips of curled colored paper.

3 1/2 inches

1 3/4 inches

Back

Pencil

☆ *How to curl paper.*

Pull firmly

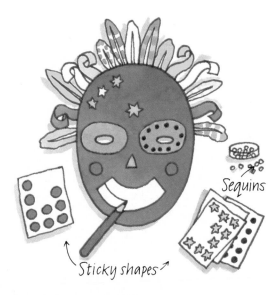

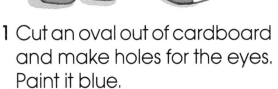

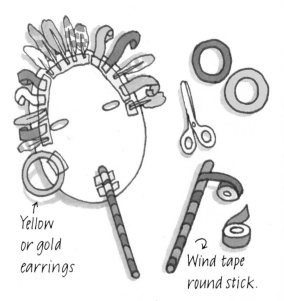

3 Paint around the eyes, mouth, and nose. Draw in the teeth. Decorate it with sequins or sticky shapes.

Sequins

Sticky shapes

4 Firmly tape a decorated stick on the back. Tape on two paper earrings.

Yellow or gold earrings

Wind tape round stick.

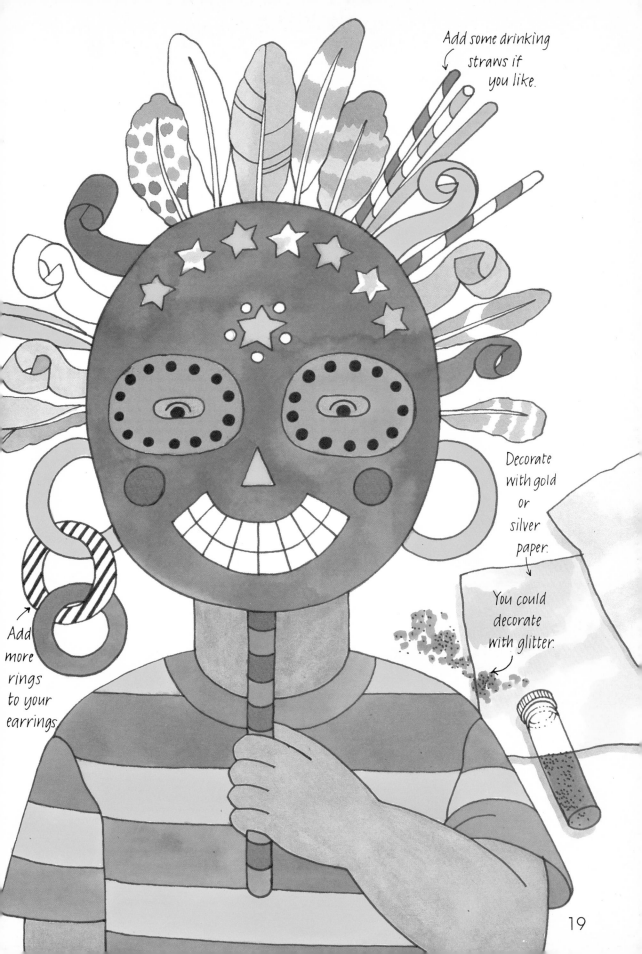

19

Car

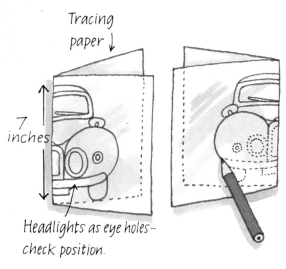

Tracing paper ↓

7 inches

Headlights as eye holes –
check position.

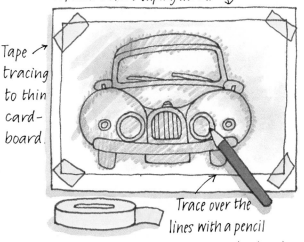

Rub over the back of the tracing with a pencil before taping down. ↘

Tape → tracing to thin cardboard.

Trace over the lines with a pencil to transfer the drawing.

1 Draw the outline of half a car. Turn the paper over and trace the second half.

2 Open it out and you have a complete matching outline. Trace it onto thin cardboard

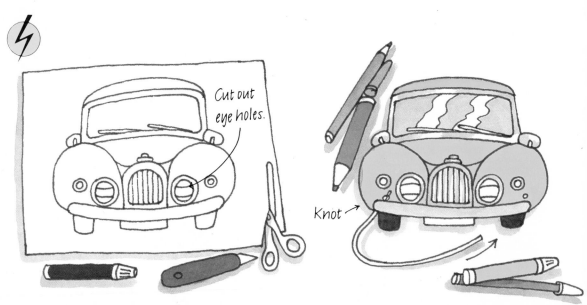

Cut out eye holes.

Knot →

3 Go over the outline and the details in black felt-tip. Cut out the shape.

4 Color in carefully. Make two tiny holes. Put in the elastic and knot each end.

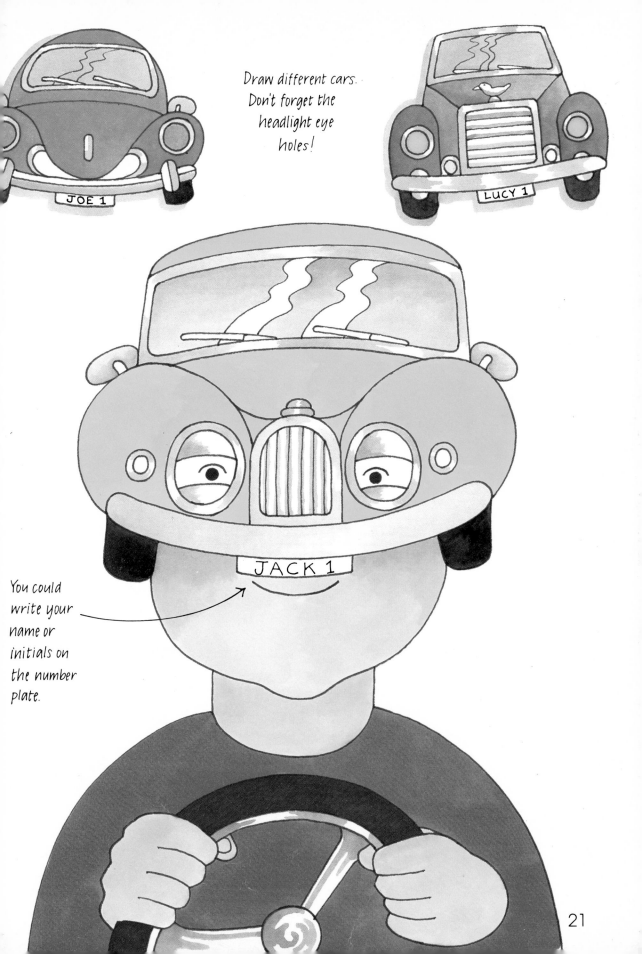

Draw different cars. Don't forget the headlight eye holes!

JOE 1

LUCY 1

JACK 1

You could write your name or initials on the number plate.

21

More ideas

If you enjoyed making the main masks, try a few more!

There are no step-by-step instructions for these masks but you can use many of the same techniques as the main masks. Look back at the page number shown in a circle like this: (16)

Some of these extra ideas go well with the main ones if you are making party masks for a friend and yourself.

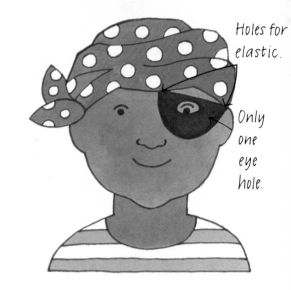

Holes for elastic.

Only one eye hole.

Pirate (8)
Cut a scarf and eyepatch shape out of cardboard.

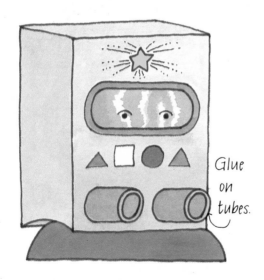

Glue on tubes.

Robot
Paint a cardboard box. Cut a see-through window.

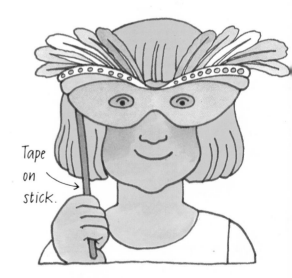

Tape on stick.

Fiesta (10) (16)
Cut out of cardboard. Decorate with paper and feathers.

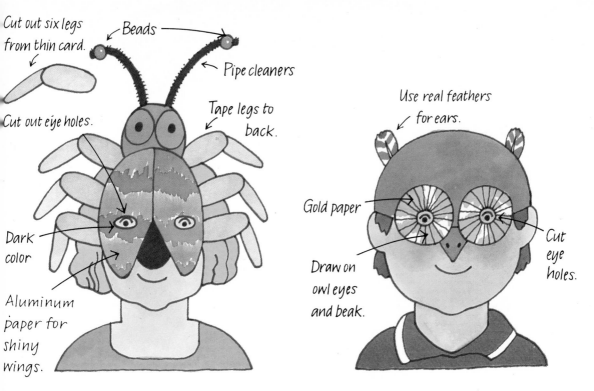

Cut out six legs from thin card.

Beads

Pipe cleaners

Cut out eye holes.

Tape legs to back.

Use real feathers for ears.

Gold paper

Draw on owl eyes and beak.

Cut eye holes.

Dark color

Aluminum paper for shiny wings.

Beetle ⑫
Draw matching halves and transfer onto card. Decorate as shown.

Owl ⑧
Cut the shape out of cardboard. Stick feathers on for ears.

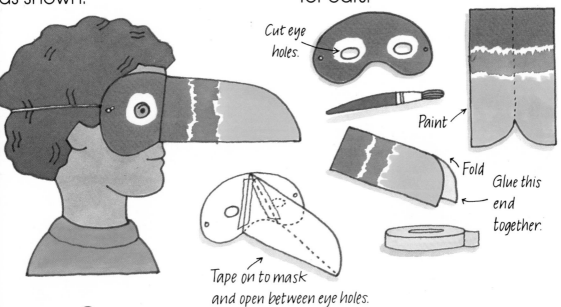

Cut eye holes.

Paint

Fold

Glue this end together.

Tape on to mask and open between eye holes.

Toucan ⑧
Cut a simple mask shape from cardboard. Add a long, thin beak by taping it as shown in the small picture above.

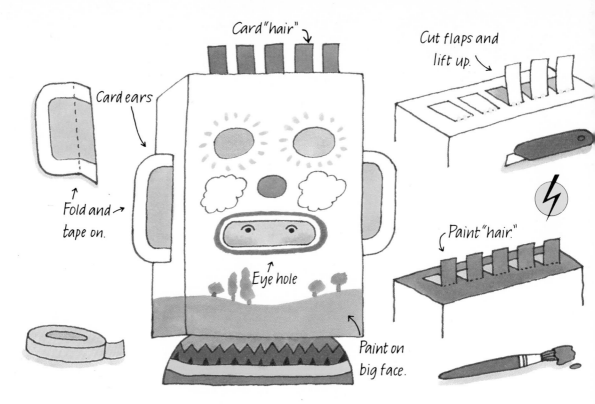

Card "hair"

Card ears

Fold and
tape on.

Cut flaps and
lift up.

Paint "hair."

Eye hole

Paint on
big face.

Giant
Find a large paper carrier bag or cereal package big enough to sit on your shoulders. Cut a slit for an eye hole.

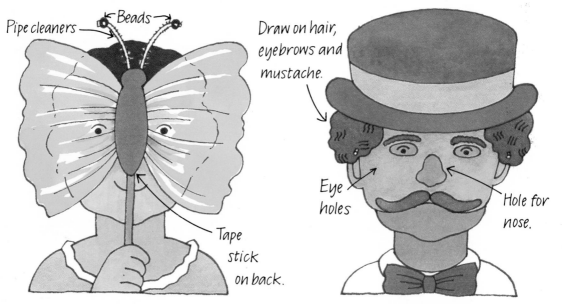

Pipe cleaners

Beads

Tape
stick
on back.

Draw on hair,
eyebrows and
mustache.

Eye
holes

Hole for
nose.

Butterfly ⑪
Make wings from cellophane or net. Tape to card body.

Gentleman ⑫
Cut shape from cardboard. Cut holes for your eyes *and* nose.